How To Draw Cartoons For Beginners

Your Step By Step Guide To
Drawing Cartoons For Beginners

HowExpert with Kim Cruea

Copyright HowExpert™
www.HowExpert.com

**For more tips related to this topic,
visit HowExpert.com/cartoons.**

1

Recommended Resources

- HowExpert.com – Quick 'How To' Guides on Al Topics from A to Z by Everyday Experts.
- HowExpert.com/free – Free HowExpert Email Newsletter.
- HowExpert.com/books – HowExpert Books
- HowExpert.com/courses – HowExpert Courses
- HowExpert.com/clothing – HowExpert Clothin
- HowExpert.com/membership – HowExpert Membership Site
- HowExpert.com/affiliates – HowExpert Affiliat Program
- HowExpert.com/writers – Write About Your #: Passion/Knowledge/Expertise & Become a HowExpert Author.
- HowExpert.com/resources – Additional HowExpert Recommended Resources
- YouTube.com/HowExpert – Subscribe to HowExpert YouTube.
- Instagram.com/HowExpert – Follow HowExpe on Instagram.
- Facebook.com/HowExpert – Follow HowExper on Facebook.

Table of Contents

Introduction

So you've decided to learn 'cartooning'. Cartooning can be one of the most enjoyable hobbies, but perhaps not at first. Creating your cartoon will take some practice and perseverance, just like any hobby does.

While it's true that talent does play a part in the ability, there are simple steps one can take to begin learning the skill that's involved. People who are able to play an instrument by ear, before knowing the notes are 'talented'. A person who learns to read notes and play the instrument is 'technically trained' A person who is talented and technically trained will master the art entirely.

If you have the talent, then this book will enable you to broaden your skills. As with any talent, the art of practicing will hone your talent and enable you to master the field. If, however, you are not a 'natural' artist, the basics for cartooning will enable you to capture special characters for whatever you have in mind. From a simple cartoon to a highly complicated animated scene, this book will enable you to move forward in the ability and skill.

Regardless of what your purpose is, with any ART, the best thing to remember is to have FUN and let your pen do the work.

'he purpose of this book is to aid you in finding a way
ɔ create memorable and fun cartoon characters.
ʾartoons have been around since the middle ages, but
hit a new level in 1910 and has since flooded the
ʾorld with laughter and joy for children and adults—
ɛneration after generation. Cartoons were created in
ɪe middle ages as a means of communication and
ɪformation. Cartoons were used as an alternative to
•hoto like' art. Before cameras could capture a
ɛrson, posed for a painting, an artist was hired to
ɪpture their image accordingly. The images were

typically stone faced and needed some lightening up, these cartoons began to ripple in as an alternative to these sour puss faced images.

Yet, cartooning is nothing more than an act of illustrating. Illustrating has been going on since the caveman days. Cartoons-like characters were drawn on cave walls, trees, rocks, etc. as a way to communicate and record stories. In a way, cartooning has been around longer than writing.

Artists have also looked to the stars too for inspiration. The visually designed constellations were inspired by merely playing connect the dot. The big dipper for instance is nothing more than that; a dot to dot image.

Cartoons tell stories. They can tell a short story or a long one. They can be recognizable or unique. The How to Draw Cartoons book is here to aid you in finding your *inner-cartoonist*.

Along the way, you will find icons that will provide you with tips for the trade, testing of the tips, and creative moments for exploring. Take the time at each icon to practice what you've learned.

ICONS ARE AS FOLLOWS:

⊙= Tips

✍=Test

⌘=Create

Drawing a cartoon can be as easy as A B C. Although it may take some time and practice, learning some simple tricks will help get you started.

From the time I could hold a pencil, I've found the need to either draw or write. While I am a professional writer, I also do a fair bit of cartooning. My children's books are personally illustrated and it's a fun thing to be able to do.

Looking at the example above you might be inclined to believe that this came easy for me. Not initially. In fact, I went through about a dozen or more sample sketches before I found the right character. That's one thing you will need to be prepared for, practice and commitment. If you are truly serious about cartooning, then be prepared to spend some time practicing.

Often, I find that if I go for a period of time when I am not 'doodling', then my skills become a little rusty and I must begin the art of practicing all over again.

Through the course of the book, I will show you how to begin drawing simple images, how to hone them, and then how to build upon each of these steps.

Don't be afraid to make mistakes. In fact, if you look at some of the cartoons on the market, many are quite simple—yet forgiving. That's the great thing about cartoons. There is more flexibility in creating them than perhaps any other art form.

Know that every cartoonist has his strengths and every cartoonist/illustrator has a weakness. I am not

in any way a "FANTASTIC" artist. Yet, when I create a cartoon, the intended audience can identify with it and that is the nature of cartooning.

My weakness, as personally identified, is I cannot draw "SCARY" which is perhaps why I write and illustrate with children in mind. My "SCARY" tends to look 'cute'. No matter what I do—whether it's a lion, tiger, bear, dragon, or snake—it always ends up looking cuddly.

In either case, you are in need of "LEARNING HOW TO DRAW CARTOONS", and that's what I will do for you. I will provide you with some basic tips and instruction to help you get started and continue growing.

Regardless of what you intend to do with this new skill, just remember to have fun! It's the best part about cartooning.

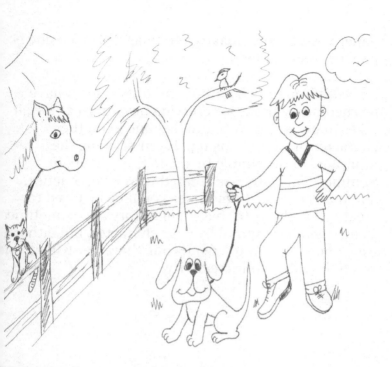

While creating a story book image may seem a little
intimidating, it really doesn't have to be. Cartoons are
one of the most versatile art forms. Basic characters
have as much impact on the masses as highly details
characters. A character like Caillou or Toopy can be
created easily and the kids will love them! While
something complex like Snow White may be
overwhelming, it doesn't have to be. With some
practice and patience, you will be able to master the
character style that fits you best. Like any artistic skill,
the more you practice, the better you'll get.
Personally, I have found that if I don't draw for a
while the ability needs to be revisited.

The making of this book required many 'doodled
drawings' and it was unfortunate that many pieces of

paper were used to make ONE image. The upside is paper is recyclable.

As a children's book author and illustrator, I have learned many tricks for creating new images. Yet, it takes many test runs to finally hone in on the character of your choosing. From drawing the dinosaur, to the simple turtle, to the rangers in Summer Falls; all were created with love, practice, and many errors. Sometimes you'll be inspired to create your character based on a story and sometimes a story will be inspired by your character, but either way, knowing how to create your character will enable you to broaden your creativity.

Getting Started

Before you begin creating your animal, person, or object, you should begin in the appropriate place; the beginning!

Whether you want to draw a cuddly lion...

An angry man...

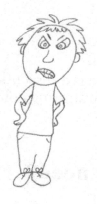

Or a mouse at the beach...

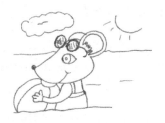

Or a popular character...

Knowing what to use is as essential as knowing how to draw. Here are some starting points:

What do you need?

Before you kill too many trees, start with scarp paper. If you have old papers lying around the house or

office, you can use the backs of them for practice. Use the good materials for later.

Basic Supplies:

Tools used in the world of cartooning:

Dollar stores are great for many things, but when it comes to buying quality products, you may need to spend a little more.

- Scrap paper for practice drawings.
- Quality paper for final sketches.
- Quality Drawing Pencils.
- Plenty of Erasers.
- Black Ink Pens (or fine tip Sharpies).
- Coloring Supplies will vary (Pencils, Markers, Paint, Photoshop)
- Patience.

Scrap Paper—Use any old papers you have around the house.

Quality Paper—You don't need expensive 'sketch paper' for this as much as you simply need good quality art paper. Some sketch paper is meant for smudging effects. If you plan on coloring your images, you want to avoid smudging. Print paper is a good choice. It's cheaper and you can get a lot more out of them. If you intend on painting, however, you will need a much sturdier paper. Paper should be able to withstand ink bleeding and multiple erasing strokes. Cheap paper tends to fray and whither the paper away.

Quality Pencils—H2 is typically fine. You don't want a pencil that smudges terribly. However, for more defined images—requiring shading, you may wish to invest in a set of art pencils that are created just for this; they vary in lead thickness and density.

Plenty of Erasers—You will use a lot of erasers. Avoid the kiddie erasers. They tend to smudge. A good hearty eraser will be able to withstand multiple strokes without withering away too quickly. Erasers on the end of your pencil may be all right for small adjustments, but for bigger territory you will want to use a sturdier one.

Black Ink—If you want to have crisp lines for your art, a quality fine tipped black ink pen will do the trick. The finest tipped Sharpie pen will provide you with the smoothest surface. You may also wish to use a variety of thicknesses and even have a few colors on hand to aid in the development of your final product.

Coloring—While most cartoonist find their own MOC (Method of Coloring), many are opting for Photoshop (or similar) programs to complete their final image. This is an optional method. Cartoons done in ink or paint are just as interesting as Photoshop.

Patience—Trying to master a character takes patience. Trial and error—error and trial. You may have to draw and re-draw your image fifty times before you find the look you're seeking. If you find yourself getting frustrated, take a break or try one of the tips.

Having the right tools and attitude is going to help you immensely in the process of learning how to draw

cartoons. Don't be afraid to make mistakes and don't allow yourself to become so frazzled that you give up loving the art. Trial and error is a part—a necessary part—of cartoon drawing.

Lesson One

Drawing a cartoon is as easy as A B C. Here's what I mean.

Start by drawing the Capital A, the small letter b, and the cursive small letter c. Use penciled lines—3 in total.

Like this...

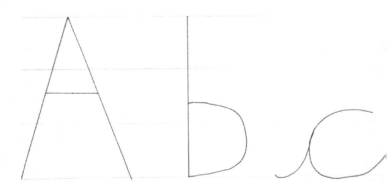

Tip:

Any cartoon you create can begin with the same principles you use for writing a number or letter in the alphabet. Feel free to draw lightly ruled pencil lines to aid you in keeping the images crisp. Keep in mind, that this is just a starting point. As you progress, you will be softening corners and filling in spaces to creat your image.

Draw three penciled lines onto a piece of paper, using a ruler, then ruler in the Capital * A *, like this...

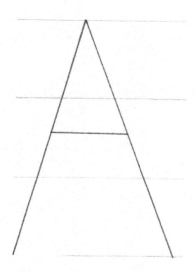

That's simple, right? You learned to do this in kindergarten and grade one. Drawing cartoons begins the same way. Once you get the knack for it, you won't need a ruler any more.

Now, take a look at the letter. Does it look like anything other than the letter A to you? Look at it carefully and jot any ideas you have.

Now do the same with the small letter * b *

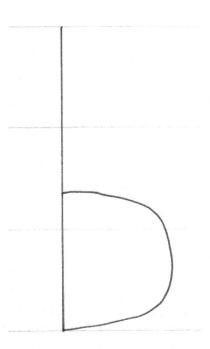

What do you 'see' in the letter 'b'?

How about doing the same with the small cursive * c

Does this look like anything other than a cursive *c* to you?

Did you find something new in any of the letters?

If yes...then you're on the right track, if not then try this.

Look at the letter A again.

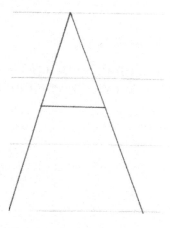

Now add some wavy lines beneath the line that makes the inverted A into the capital

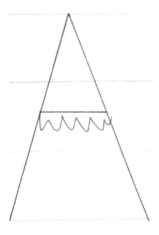

You've created a mountain with a peak. Overlap a few with different sizes and you have a mountain scene...

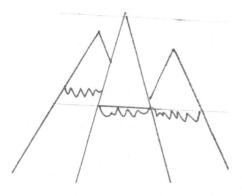

Try turning the A upside down and create a semi-circle across the opening.

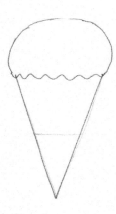

The beginning works of an ice cream cone. With a little softening and shading you can create the image to look more like this...

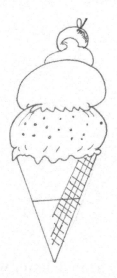

1. Try turning the original ice cream cone shape back upward, and then add a face. Two dots for eyes. One small printed c will work for a nose. Add a wide U for the mouth.

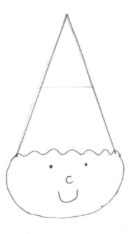

2. Add another c to the left side of the head and a reversed c to the right side.

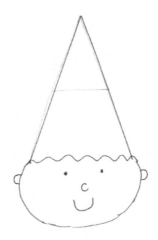

3. Now, try adding a small letter w three times below his chin, two below his nose, and two small m's above his eyes.

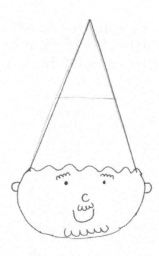

4. Now try connecting the tips of the w's and m's together and on the brows and moustache. Then create two lines from the tops of the w's on the beard and run them to the lower part of the c' ears.

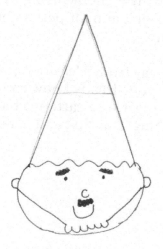

**While the image is still in rough shape, we are slowly creating a character...let's keep going.

5. To the face we are going to add a wide U from th[e] small c's ears below the chin [color it in], and then p[ut] two large circles around the dotted eyes.

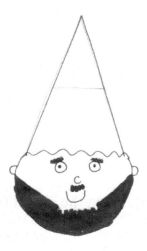

✍=Test: Try drawing a gnome using the upside dow[n] ice cream cone. Don't aim for perfection; this exerci[se] is for practice only.

While it's a long way from a 'cartoon', you can see ho[w] using a few skills you already know can provide you with some aid in creating a cartoon character. With [a] little more sketching, coloring and detail you can en[d] up with this...

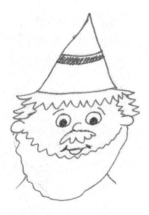

Now let's try the same principles using the small letter *b*

What can you see in this *b*?

In this position you could be looking at a foot. With a few alterations, you can end up with this...

Now try turning it to the left 90 degrees. Add a dot at the top and create an upside down *V* [the v does not have to be perfect]

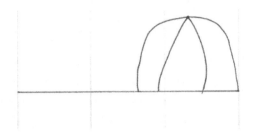

You've created a ball cap! With some adjustments you can end up with this...

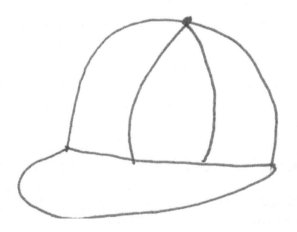

You can adjust the top or the brim according to your character's needs.

What about the small cursive *C*? What can you make with that?

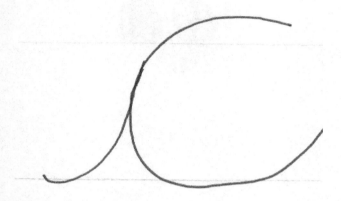

Add a triangle at the tail that loops the C, color it in,
extend the curl to the left. Then add two partial c's to
the sides of the tail and opposite side. Then add two
small letter "n's", followed by two colored o's.

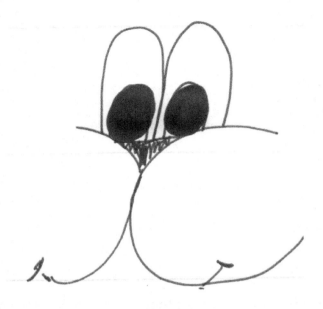

You've got the makings of an animal's face.

Tips:

You can find ART in everyday shapes and objects.

Now that you've learned you're ABC's again, try this task.

⌘=Create

Try using a large *O*, use the sided small *b* and place that on top of the *O*. Then use the c's trick we used above to create two ears. Use the c to create a nose. Use the cursive c sample to create the face. Use a pencil at first, then erase the extra pieces, go over it again with your black ink pen and see what you create.

Use three little dots on the cheeks to add the special finishing touch—you should end up with something like this. If not, try it again and then again.

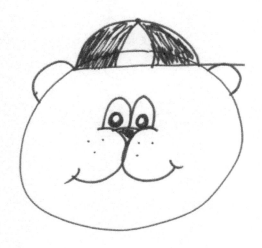

Did you create the teddy bear face? Can you see the letters b and c and how we used them?

The large *O* is the bear's head. The sided *b* is the all cap. The two printed c's (forward and reverse) make the teddy's ears. The cursive *c* makes the mouth. The colored triangle makes the nose. The two 's created the eyes and the two o's created the pupils. By adding the six little dots we created some definition to his face.

With some line softening and details you can end up with this...

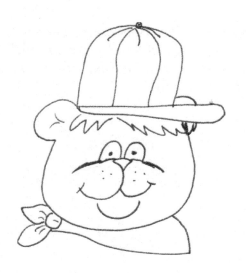

Lesson Two

Make a squiggle into a character

What if you're creating something that simply looks like a scribble? Can you create a cartoon out of that? Sometimes it can be fun to create an image from nothing. See this step by step instruction on how you can do the same.

Here's what I mean. Here's a 'scribble.'

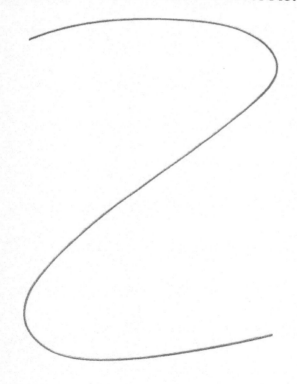

How can this scribble be anything?

Watch and see. We are going to add some shapes now.

Using the tools we learned with our ABC's and shapes...Add an oval to the right side of the scribble and a circle to the left. See anything yet?

Keep watching... Now we're going to add ½ of a large *O* and put a smaller *O* inside of it to the OVAL shape on the right. Then add ¼ circle to the half O, added by a few 'stitch' marks along the line.

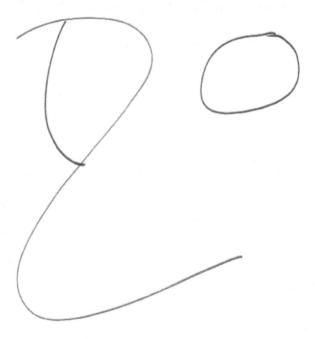

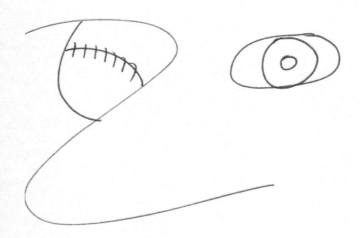

So far we've created a nose, an eye, and a baseball smacked into the left eye. We will now create some stars around the baseball. If you can't draw the star shape, simply do two triangles inside one another. Then, for the right eye, we will create a half arched brow. Below the nose (about half way) create a lose capital *L*.

Our character's been hit with a baseball and is seeing stars. You can create the rest of the face by using the side *b for a baseball cap, the backwards *C* for an ear, and a candy-cane chin to the ear shape; like this.

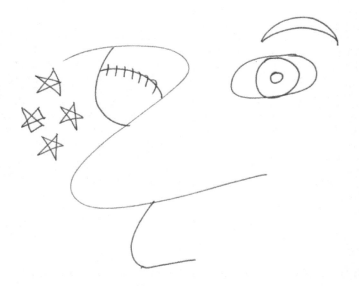

⊙ = Tips

You can find ART in an imperfect scribble or line.

A scribble became the face of a character who's been hit by a ball, but adding some shapes, some letters, and a few extra scribbles for the hair. Although it's still 'amateurish' in appearance, you can certainly see how this will progress for you.

⌘=Create

Try the scribble exercise. Create the backwards *S*, add the shapes suggested and see if you can create your own injured baseball player. Keep trying if you don't get it the first time.

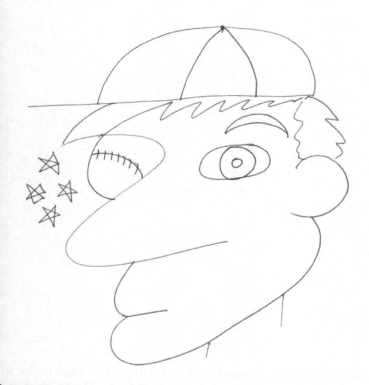

an you see another image in the same scribble? Try
hanging the top of the head, continue the nose line to
1e ear, remove the ear, and create zigzag lines. You
1ight end up with something like this...

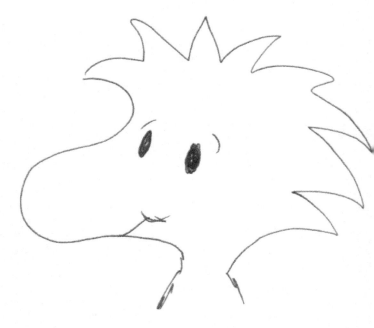

Look familiar? He only seems intimidating, but he's not. Woodstock is as a simple as the scribble above. With a little practice you can draw him too. Don't be intimidated. Be inspired...

Lesson Three

Creating from an existing image

This may seem silly, but if you can see a character in an odd object, then you will definitely find cartooning enjoyable and relatively easy to do. To explore your creative side further, try finding ART in objects that already exist.

Try this picture.

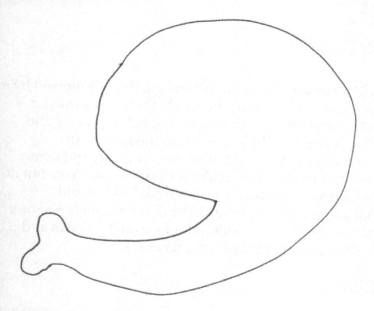

It's a chicken leg. What can you make out of this? Impossible? Try this...

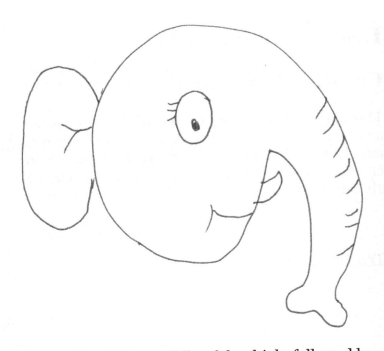

Add a black O in the middle of the thigh, followed by a very large *C* behind the thigh, then add some lines to the leg bone. It's in rough shape, but you get the idea. A chicken leg just became the face of an elephant. I simply added an eye, and ear, and some wrinkles to the leg to make it into a trunk. You can do this with any picture you can find. Find an old magazine, cut out some of the odd food pictures, or a tree, or even a shoe and put a face on it. Rocks and fingers are great for putting faces on.

TEST:

See how many objects in your current space could have a face with a few eyes and a mouth. Can you see it?

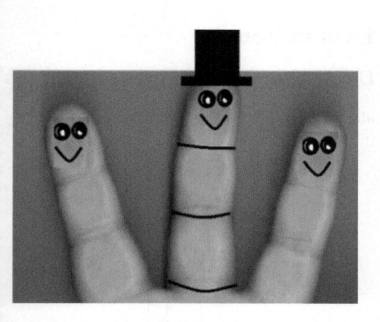

ry scanning your hand and then make your fingers
ito worm characters. You can add a top hat by using
ie PAINT or Photoshop programs.

oes this seem silly? Perhaps it is, but you are
reating cartoons and silly is a part of the creation
rocess. This exercise it intended to help you see the
CHARACTER" in just about anything.

Lesson Four

Using every day shapes

Making a house is probably the easiest drawing you can ever make.

A square, a triangle, a rectangle, and maybe a few more squares.

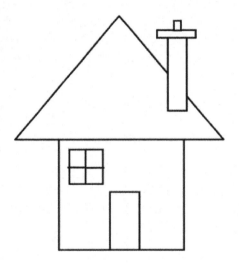

You can do that. Now try making a Christmas tree. Use a rectangle and a triangle.

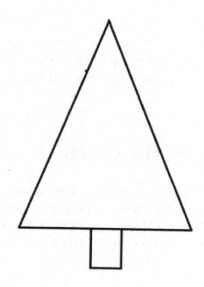

Try making a car with a series of squares and circles.

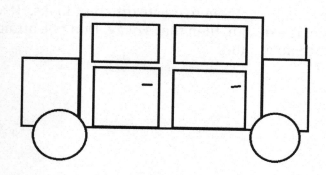

Use as many of these tricks and tips to begin your
scenic creations.

ow, you've got the ABC's for people and animal
eating and you got shapes and scribbles to help you
ith props or accents.

TIP:

Once you've created your BOX car with a pencil, soften the corners to shape the car more effectively.

Combining these tricks

Everything you've learned to this point has provided you with tools and tricks to help you get creative and see the ART that's already around you. If you are abl to see a rabbit in the clouds, then you are on the righ track.

Create

Take two triangles, two circles, a square, and an oval try over lapping them to create different looks. If all you get is a design, then that's okay. Don't be afraid t move them around.

Lesson Five

Creating a Cartoon Animal

To create a mouse: start with a series of different shapes. You will see the different shapes in this character. Rather looks like a silly robot at the moment. Use pencil when creating your character. I've done the steps in ink to aid in the printing process, but note the rule for penciling above so you can erase the unnecessary lines.

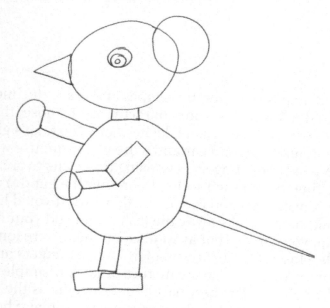

TIP:

Using pencil will help alleviate the stress of making mistakes. You don't need to INK the work until it's ready.

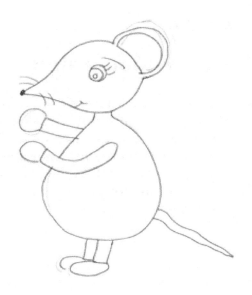

Next step is to soften the shapes and erase the lines you don't want for your character. Add a nose, the inner ear, some whiskers, lashes...etc. Next, let's give the mouse a second ear and a dress. The mouse will also need some fingers. Try using tiny ovals to create the fingers and then soften them into the hand. You don't need a second eye for a side view. If you'd like to add hair, or take away the lashes and add your ball cap, you can do that as well. Open fingers are long ovals, closed fingers are smaller. Use 3-4 fingers and a thumb. You can also create toes or keep it simple by adding shoes. The best part about cartoons is the fact that you don't have to have toes on an animal. Shoes will work too.

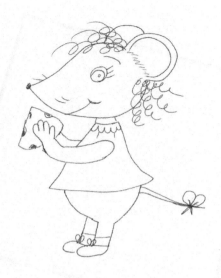

Were you able to create your mouse? If not, keep trying.

Keep trying and you will eventually fine tune your lines more to create something like this...

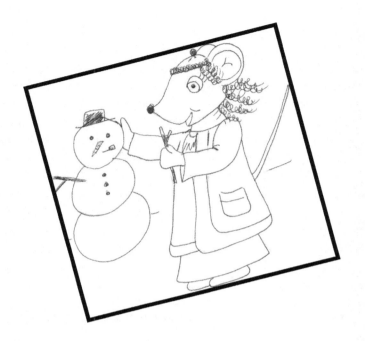

Different shapes will work to create different animals, objects, or people.

Try creating a frog.

Football shape, circles, oval shapes...

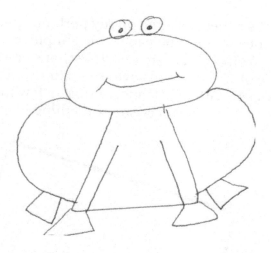

Now work on softening the edges, add a lily pad
around his bottom (circular shape), round his belly,
web the feet. Create a few black balls by his head with
tiny circles to create a fly with wings.

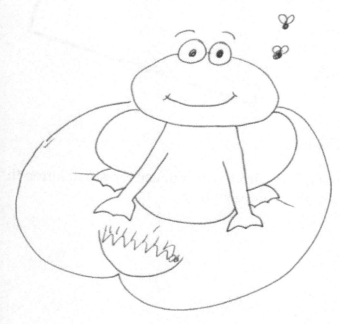

49

It's a messy sketch on my part, but this gives you an idea of how you can create simple cartoon animals. You can also create a frog that's erect and wears clothing; we will cover that after we try some more tricks. With a little more effort, a few more details and you can create something like this...

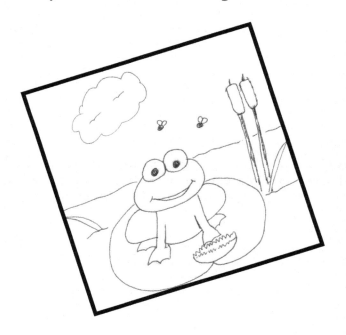

⌘=Create

Create a frog with a ball cap, use the small letter *b* accomplish your own frog.

Lesson Six

We've reviewed some basic shaping in the previous lessons, but now it's time to create these shapes and letters into actual objects. In the following lessons you will learn how to create simple shapes into body parts and other animated objects. Let your mind visualize as many alternate shapes as it can. Creativity should not be harnessed as you learn how to create your cartoon art.

Animal Parts

To create an animal, you should be able to create their face, their body, their tail, and their paws/legs. We will take you step-by-step on creating a full creature, but here are a few parts you can practice drawing. Learning how to draw these parts individually first will aid in the final creation of your cartoon character.

Tips

Writing a book is done by writing one word at a time. Creating a cartoon character is done by creating one part at a time.

Tails

Any one of these tails can be hand drawn, but if you are in need of a guideline, remember to use ovals,

circles, and other letters. If you look closely you will see at least one of the shapes in each of the tails.

Raccoon Tail (Created by an oval)

Squirrel Tail (Created using a capital P)

Rat, Mouse, or Opossum Tail (Use an imperfect line to create a length and then double back over it with some width at the one end. Create lines in the tail if required.

Chipmunk (A distorted triangle will aid you in getting this tail look.)

Horse or Pony Tail (You can create this tail using a loose formed number 2)

Lion's tail (Draw a candy cane or upside down J and leave off the line. Add a bit of fluff at one end)

Monkey Tail (use the letter S, keeping the bottom o
the S loose)

Dog's Tail (a very long and thin triangle will create this tail, simply put a twist on it and some dashes on either side to make it look like it's wagging)

Paws/Feet

Animals must have the perfect paw, right?

No, not necessarily. Animals in some cartoons wear shoes and gloves, but for the animal that needs to 'look the part', some simple tips will help you create that specific look.

Forward Paw can be used for dog, rabbit, or bear. To make it more cat like add claws to the toe region. (A capital U tilted)

Side paw. This can be used with many four pawed
animals. (Created from a small letter d)

For a raccoon or monkey, use a human hand. You may
of course use a 'human hand' with any animal, if you
choose to so. (Many of the Disney and Warner Brother
animals have hands and shoes. The exception lies
when the story calls for more realistic animals. For
now, however, have fun playing with your character's
look.)

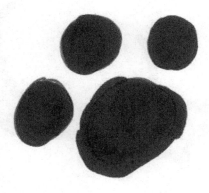

Paw Print, you can use this for a general paw print. While it is not an identifiable paw print, it allows a child to understand the image's purpose. (Simple O's)

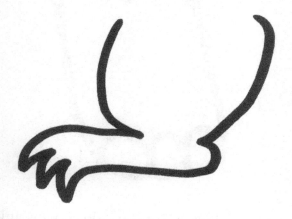

Rodent foot. This can be used for mice, hamsters, rats, squirrels etc. (Combination of the letter U, and oval shape, and the letter M)

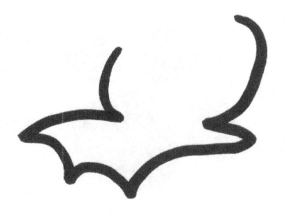

Webbed foot for frog. (Combination of letter O and a wide M)

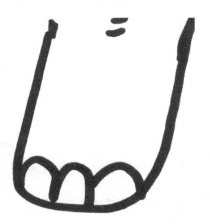

Elephant foot. (Letter U and n)Add some wrinkles and toenails for the finished look.

Animal with hoof (Created from the capital H, extended at the top. Then create a close at the bottom, create the divot if required)

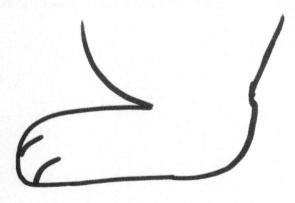

Rabbit foot [or alike]—(You can create this foot by using an oval and circle. Blend the two together and add some lines to the foot to divide the toes)

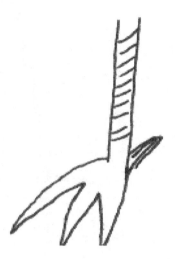

Bird foot. (You can use a backwards L with the lette
M or use a combination of triangles and a rectangle

Webbed bird feet are similar, but wider and instead
the wide M, make the M looser as it links the toes)

Other Parts

Fish fins

Noses

Noses vary, but a few can be used over and over again, with slight variations to create your unique look.

Remember our cursive C? That's a good place to start to create a nose like this...

Add whiskers of fluff to define your animal.

To create this bear's face, use a boxed C's

A weasel/mouse's nose can be created using either a triangle or side V shape.

This cow/hippo nose can be created using a large C.

This bird's beak can be created by using a triangle or V shape.

The noses will vary, but practicing with different shapes and angles will help you move forward in the cartooning process.

Ears

ears are fairly important. It can make the difference etween making your character a cat or a rabbit. amples below will aid you in creating more defined ars. Many are interrelated and you will be able to xperiment with them.

A teddy bear's ear can be created using an incomplete O or a rotated C.

An erect, pointy ear can be used for cats, some breed of dogs, pigs, cows, and more. The size and where they are placed on the head will aid in defining you

animal. To create and erect ear you can use a triangle, diamond, or the Capital A.

This droopy ear works for lop-eared bunnies, donkeys, and some breeds of dogs. You can make this ear by simply making a droopy S and a reversed droopy S for the opposing ear.

The tall erect ear is most likely to belong to a rabbit, but this ear will work for a kangaroo as well.

⌘=Create

For the billions of animals that walk and crawl on this planet, there's going to be an ear that's just right for them. Try creating an oversized ear and then try to create a hamster's ear. See how diverse they can be. Keep in mind, some animals and creatures don't have visible ears.

Lesson Seven

Creating people

People are often harder to do then animals, but you can use the same principles as you did with the animals.

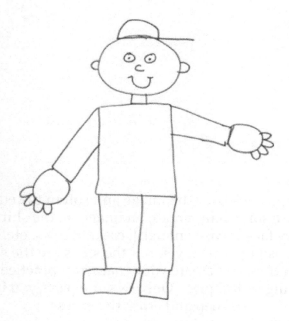

Try creating circles and squares for your person, the add some of the alphabet tricks to create your image. Don't worry if it looks silly or amateurish. You are learning to create the image; the fine tuning will come later. Remember to do it in pencil so that you can erase the parts you don't want later.

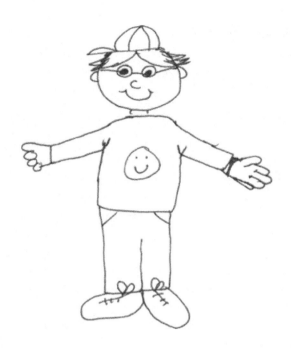

Now go back over the image and soften the edges, create some hair, create an image on the shirt [a happy face is easy enough], create brows, etc. The image isn't perfect...yet, but the steps are the same. Each time you create your character, practice the softening techniques. Only INK the parts you intend to keep and erase the excess.

Practice now by drawing some of these faces using a combination of shapes and letters.

Use an oval, heart shape, pear, round, oblong, square or triangular. Use different letters of the alphabet to create ears, noses, or eyes. You may even wish to apply simple scribbles to create a different look.

on't worry about the character's initial appearance;
e step at a time. Many, many drafts will likely be
ne before you find the 'perfect' look for your
aracter.

aces

n you see the shapes in each of these faces?

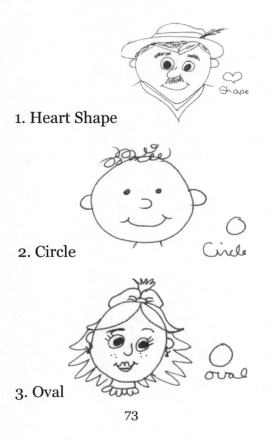

1. Heart Shape

2. Circle

3. Oval

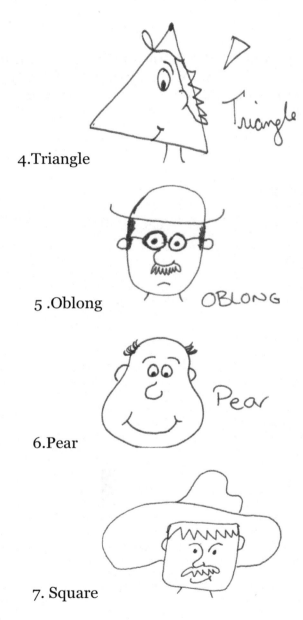

4.Triangle

5 .Oblong

6.Pear

7. Square

⌘=Create

Create a face from each shape type. Pick your favorite and draw it over and over.

To create a cartoon character for a comic strip or book, you need to be able to create the image over and over again. Try the face looking happy, sad, and angry. Once you have established his frontal look, you may want to try with side views using the same tricks.

*****Did you know that most cartoon faces only have 3-5 poses? They're just readjusted over and over to create a continuous look.******

Body shapes

People come in all sizes and shapes. Use any of the above methods to create your body shape. Try with a letter, a shape, or a squiggle. The number 8 is great when creating a female figure.

Thy these.

The letter *B*

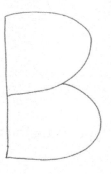

With a few alterations you can create a big woman's body; like this...

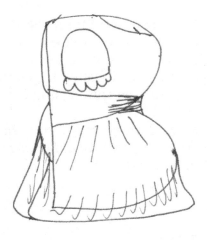

This is the "MESSY" version, but when you do it with pencil, you'll erase the excess and leave the rest of it behind to look like this...

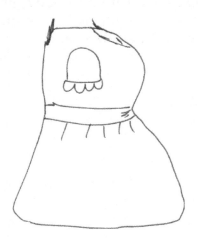

Try a body type using the number *8*

You can alter the width and size of the 8 to accommodate your look.

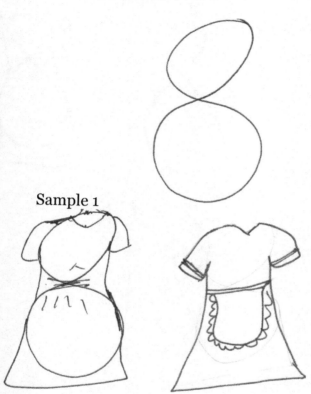

Sample 1

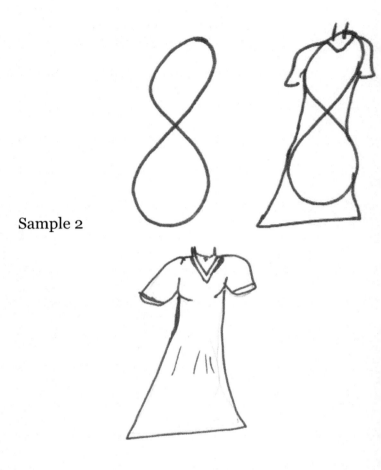

Sample 2

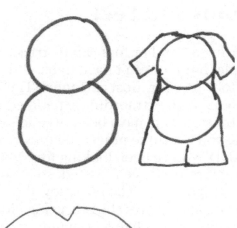

Sample 3

...e started with the number eight in three different
...rieties, added a few smoothing lines, erased the
...cess, and added some details. You've just created a
...dy.

...st

...y using the information in this section using
...fferent letters, numbers, and shapes to create your
...n body types. Use your bodies as templates later.

Hands and Feet

Creating a hand or foot can be tricky when it comes people, but it doesn't have to be. It is acceptable to use four toes for most cartoons. There are of course cartoons with extraordinary detailed hands and feet, but those people have been practicing for years. Sta basic and continue practicing until you find the "HAND" you've been looking for. Many cartoon characters are three fingered, so it's okay if you have three fingers too. The other joy about cartooning is that you can always start by using gloves. Either way practicing things like feet, hands, gloves, and shoes will aid you in creating your character's look.

Use shapes and letters to create your baseline and then smooth out the rough spots to get the images you're looking for.

HANDS

Circles and ovals

Palms up:

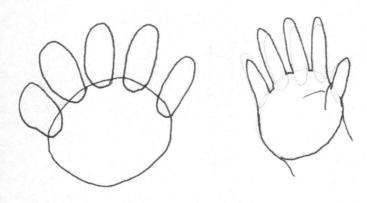

Closed hand:

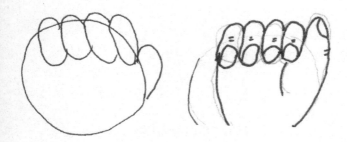

(Remember to add knuckles and nails)

For the hand against the leg, simply allow the fingers to come to an ovaled tip just above the knee region. To emphasize the finger's shape add the creases where you'd see them on your hand.

Hands in pocket

Back of open hand

Feet with shoes

While this is a simplified shoe, this guideline will give
you the basics for making a footed shoe. As you gain
experience you will be able to create more defined
footwear.

Man's Shoe

Draw an extended oval to start with.

It looks like a rock or maybe a jelly-bean, right? Now, add a thick line along the bottom and fill it in. Use extra lines to define the sole, like this...

Still doesn't look like much. Now, try adding a small semi-circle towards the top right hand side. Add a sideways *8* to create a bow. Then add a line and a series of lines or x's, like this...

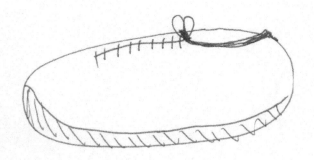

Now erase the messy opening, add a partial rectangle or square to create a sock, like this...

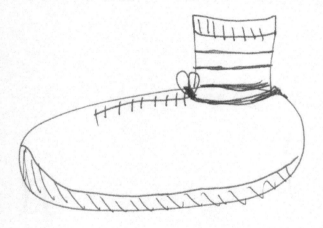

A ladies shoe can be created just as easily by curving the oval upward and then adding a long rectangle for the heel. Like this.

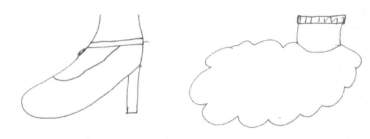

Or do a cloud shape and add a sock...

For a frontal view, do a large letter U and add similar details to create this on any of these feet, like this...

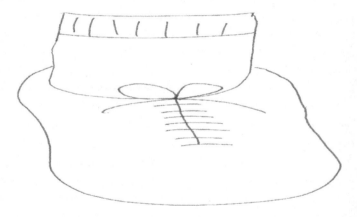

Bare feet

Tip:

Cartoons that go to the beach or take a bath will not be wearing shoes. Applying these simple steps will help you in creating feet to suite your character.

Start with a simple oval once again, just as above, and then add (For side view)

Add some half ovals at the end and shape the top to suit. Create a thicker/bigger one to make a man's foot or make it thin and tiny to make it look feminine or childish.

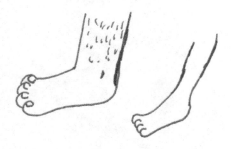

You will notice there are only four toes. You can get away with this when it comes to cartoons.

Eyes

If seeing is believing, then seeing your character with the right set of eyes will help your audience believe the mood or personality you are trying to create. Eyes are expressive, let them work for you and your character.

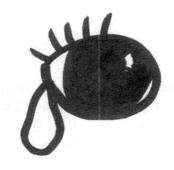

Big sappy eyes

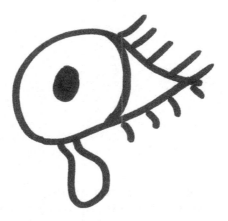

Teary eyes. (Masculine eyes don't need lashes)

Sleeping eye

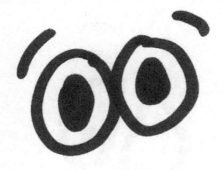

Surprised

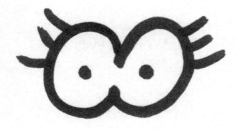

Combo eyes

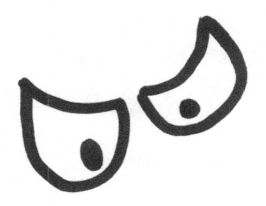

Angry eyes

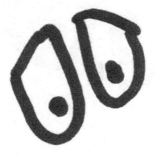

Worried eyes

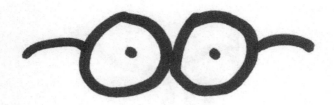

Eyeglasses

Eyes may vary from character to character. Eyes set the tone for your character. Happy, sad, or angry, eyes need to look the part. Whether you practice drawing circles or do a variety of other shapes and smoothing tricks to get your look, the right eye will take trial and error. If you can't quite figure out what the eyes should look like, use as mall mirror to capture your own expressions.

Mouths

A mouth will set the mood for your character. Smiling, frowning, or being silly are just some of the mouth features you will use while cartooning.

Silly smile

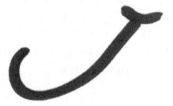

Semi-Smile

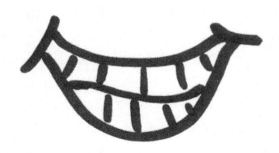

Toothy grin

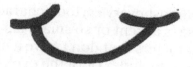

Simple Smile

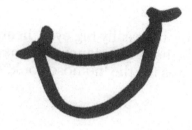

Super Smile

Sneering Growl

The mouth works with the eyes and should express the scene your character is trying to portray.

**Noses**

Noses are on almost every cartoon character, yet for some...the nose is absent or so small, it's almost invisible. (Characters that don't have a nose or only have a mini-nose include; Dora the explorer, the Power Puff girls, and Bratz) for everyone else, one of these noses may be used.

⊙= Tips

If your character has really big eyes, heard, and hair, the nose may be hard to balance. This is often when the cartoonist ops for the 'no nose' look.

C

The C nose

The droop J nose

Broad, bigger nose

Turned up nose

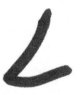

Pointy nose

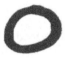

Clown or button nose

Ears

Ears are pretty simple. You can create an ear by using the C or D and then simply adjust the shape by creating extended features.

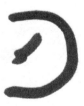

C shape, reversed for opposite ear.

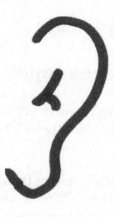

To create this ear, you can create a question mark and reverse it for the opposite ear.

The capital D is good for a more formed ear, just leave the back part of the D off, reverse the letter for the opposite ear.

Lesson Eight

Putting the pieces together

Now that you've learned how to create the shapes an parts of a cartoon, you're going to be ready to create your first image.

Here's a sample of what you can create by using a variety of shapes. Using different shapes, you will eventually be able to create images like this...

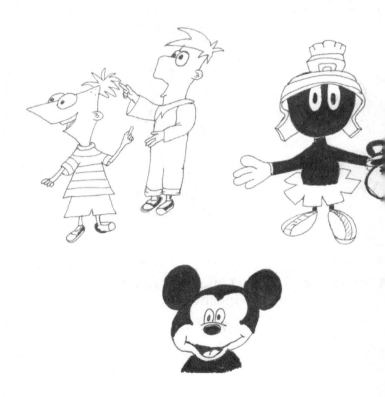

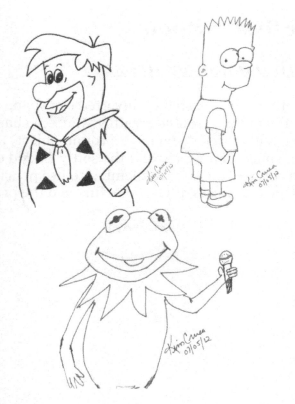

To work your way up to creating one of these characters, start by creating your own. Allow your hand to create by using the shapes you've learned and just let it flow. As you progress, try to draw a character you like by using these same shape guidelines. Use an image to ensure your accuracy. Drawing the "PERFECT" look-a-like takes many attempts for most, so don't get frustrated if you need to draw your character a dozen times before it looks right. Practice will make it perfect.

Your first cartoon...

Creating a young girl...

Start with a soft oval shape, (inverted egg shape is great). If you have trouble creating your egg shape, draw a circle (Trace if you have a round object) then create a smaller circle above it the softly extend outer lines to connect the two. Remember to use pencil and then erase the excess after you're finished the project.

Create the oval...

To this oval add the small c nose, the simple smile, and the combo eyes with lashes...

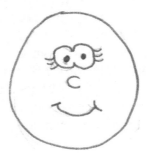

Add a neck (which is simply two lines to create a box shape), add the c's for the ears, and add two curved lines to create the bangs of your girl...

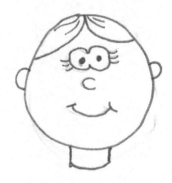

Now to add two pony tails. Create two tiny circles on either side of the head, then create to longer curves (tail) to the circle on both sides, then create the bow using a warped B and a warped W...

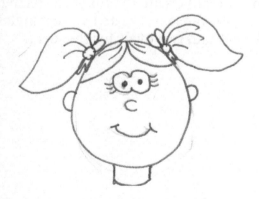

Create three dots beside the nose for freckles, then begin to create the upper torso. Create with pencil a square, but round the top corners where the shoulders will go. Then create two smaller squares to the left and right of the box where the arms will extend from...

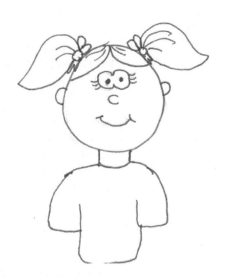

Now to create the skirt (lower part of the body), legs and feet—which will be showed. To create the skirt create a triangular shape with a loose line to connect the bottom. Do not create the tip of the triangle at the waist. Then, for the legs, create two rectangles for the legs and two ovals for the feet...

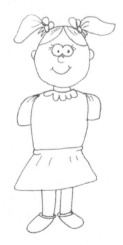

Now for the hands and arms. To keep it simple for now, draw two lines curving to the side. It will look like she has her hands behind her back, or you can simply draw the lines straight to the side. I have shown you both methods below...

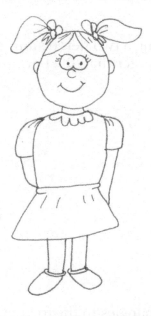

You've just created your first child! Try drawing her again and again, create longer hair, a longer skirt, create a sleeveless shirt, or a V-Neck...the options are endless. Keep the shapes method in mind to help you make the different looks.

✍=Test

Use the various parts as listed previously to create different looks.

Creating a cat...

Animals are somewhat easier (I find). This cat is eas
you can get fancier later. [this step will work with
dogs, rabbits, and mice—simply alter the tails and
ears]

Start my creating a two tiered snow man, top circle
being larger than the bottom one...

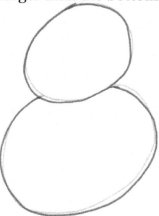

Now add two triangles to the top of the smaller ball
and an inverted triangle in the center of the smaller
ball to look like this...

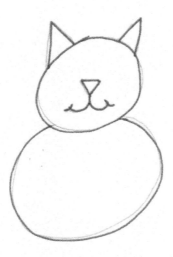

Then add ¾ ovals to the center and one to the left or right of the larger ball, about 2/3's the way down. Then finish it up with two eyes from your 'eyes' section. To create two feet simply add partial ovals beneath the first ball, like this...

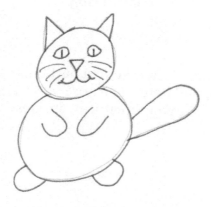

To finish him off add some stripes, or a patch around the eye. You can also use this method to create any of the other animals you like. This is a great cartoon to help you begin your cartooning experience.

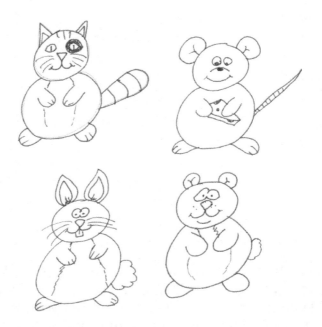

Try this method to create any animal you're considering.

⊙ = Tips

Any specific details known to a particular animal should be applied here. The nose, ears, and tail will aid in identifying your creature's species.

Lesson Nine

Upgrading your ability

Now that you can draw a few characters, you're ready to upgrade your artistic ability. The lesson herein will help you create a scene. Cartoons are created with complex or completely simple backgrounds. Depending on your audience, will often decide your background. Most pre-school cartoons have basic backgrounds, but when colored use vivid colors. Complex animation (A typical animated Disney film) will involve multiple and diverse props and background images. To upgrade to a incorporate a background, we are going to cover cartooning objects. There will be two types, objects to 'sit still' and objects that will be alive.

One of the best examples of an 'alive' object would be the film "BEAUTY AND THE BEAST" *Disney version.

Here are some fun animated 'objects' for you to create.

The Pumpkin

The Pumpkin—or jack-o'-lantern is a classic example of object made life like. Here's how to draw your jack-o'-lantern...

Create two broad C's, one will be reversed and the two points will touch, like this...

Add additional lines to the top and bottom. Then add a small square for the stem. An odd shaped oval will create a leaf.

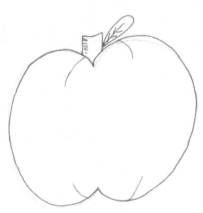

Add three triangles; two for the eyes and one for the nose. Then create zigzag lines across the face and do duplicate line above that to create the mouth.

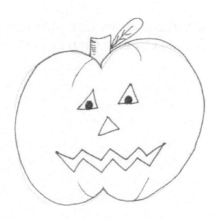

Create some dark shadowing the give it a spooky,
night effect.

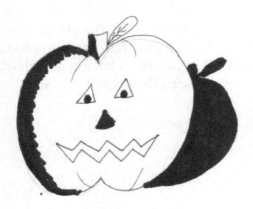

lock

Basic...Draw a 'perfect circle', use any circular object
you have to get the circumference just right. Then
create a penciled + sign in the middle to ensure the

quarters are accurate. Draw the numbers 12, 3, 6, and
9 at each quarter, and then erase the lines.

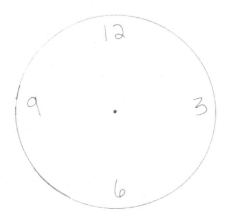

One with a face...To complete the clock look, draw tw
lines. One will be longer than the other to create the
time. Then fill in two lines between each quarter to
represent the other numbers.

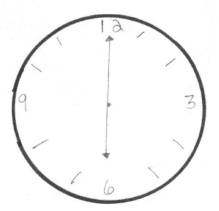

Another with a face...Use any mouth or eyes to crea
the face. Add cheeks, a nose, freckles, or eyebrows a
you wish to complete your clock character. With th
face you can create a wall clock, a grandfather cloc

(using a series of rectangles), or if you feel daring enough you can create a mantel clock.

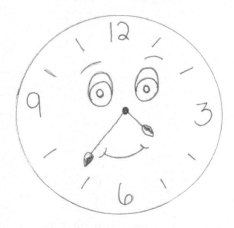

A Fruit with Personality

A piece of fruit or a piece of fruit with personality.

Here's a banana...Create a curved line and a second curved line beside it widening in the middle. To create the peel, simply do more 'curved' lines with points. Add a few lines to create the depth of the peel. The fleshy part of the banana should have a rounded top. If you choose to make it look like it's been eaten, create a zigzag along the top and remove the rounded top.

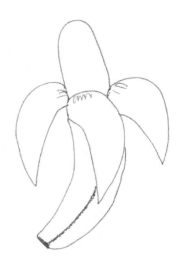

This banana has an appealing personality...To create this look, simply add a hat, two eyes and a mouth. This is one of those times when a nose may be left off to create the look you want.

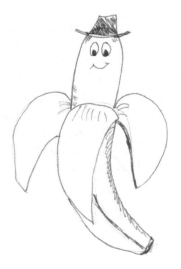

Broom

A broom... To create the broom, draw two lines side by side. Then curve the top to join the two together; this is your handle. At the other end create a LARGE B shape, with both sides of the broom. Create the zigzag at the bottom to indicate bristles. Then, to complete the look, create two lines where the B's bend and then add some sketch lines to create additional bristles and texture.

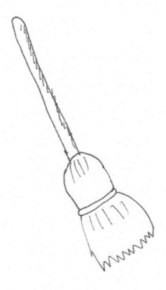

Or someone who will sweep you away...With your broom, simply add two eyes, a mouth, and hat to create your character. Arms and hands are optional of course, but may create the personal side of the object.

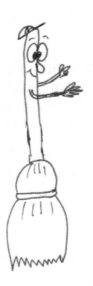

Lesson Ten

Animals and animals with clothing

Something that's rather fun about cartooning is creating your everyday house cat into a vertical, walking and talking character to thrill your intended audience.

A cat, while in its typical form may be able to communicate. Animals in cartoon films such as the Aristocrats from Disney* or Garfield are examples of cartoon that talks, but appears 'purrfectly' cat.

Tom and Sylvester are two examples of cats that walk erect, talk when required to, but they do not wear clothing.

Cats with clothing include *Hello Kitty* or Snaggle Puss and Pink Panther who wears some clothing, (hat, ties)

Variations of animal looks provide an endless opportunity to create YOUR special character. Earlier you learned how to do a basic cat. Now you are going to learn how to draw an erect cat with some clothing on. To keep it light, we will simply apply a hat, T-shirt, and sneakers. Here's how to start.

The upright cat with no clothing...

Create your cursive c face. Add a rounded letter M
above the nose and create your pupils by adding dot
or ovals.

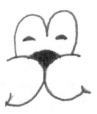

Now add a semi-circle above the eyes. Then create
two triangles on either side of the head. Do a secon
triangle inside the first to create the inner ear and
some tufts of hair at the base.

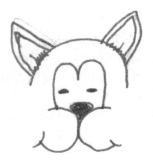

Below the mouth create a wide U for the chin (or
semi-circle). Then close the space between the uppe
space and the lower by creating multiple curved
line/zigzag pattern to create fuzzy cheeks. Finalize t

face by adding a few whiskers inside the cursive space, like this...

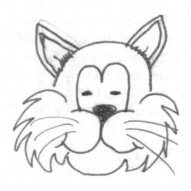

To begin the body, create a droopy oval beneath the chin, like this...

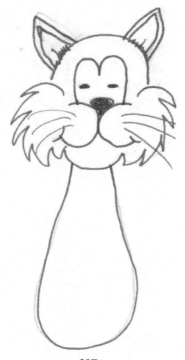

To create the rest of the body run a second line over the first about ¼ of the way down the body and extend it to the legs. Create a wide bottomed W to create the rest of the legs and the space between the legs. Add an oval to the bottom of the leg where the ankles will go. With the arms, create two lines running from the neck to about ½ way down the body (any angle is fine) then match the line beneath it. Finally create two more ovals where the wrists will go, like this...

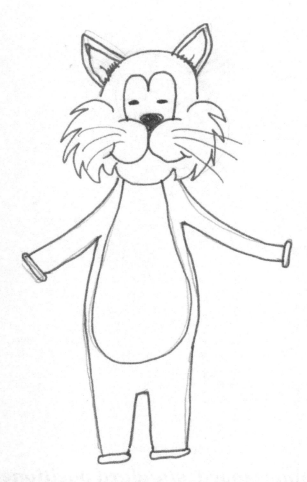

Finally, to complete the look, create the paws of your choice. You can simply at a mitted hand and oval oot, or add a few fingers and toes. To finish the look, don't forget the tail; create a very long curvy oval at the hip height of the body, like this...

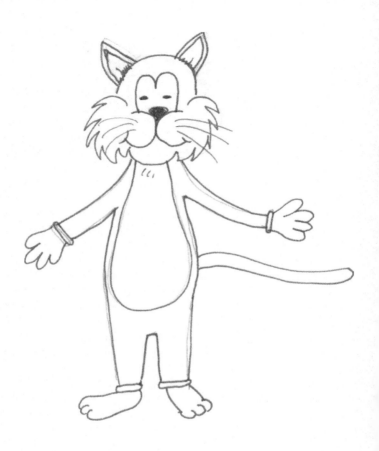

The four legged, standard positioned, cat...

It doesn't have to be complicated. When first starting out, you can simply avoid certain angles or features until you are more comfortable with broadening their look. Here's how you can draw a cat sitting on a fence.

To begin with the four legged critter, start by creating
two circles. One inside the other.

To create the ears, add a shaped triangle to the head
at the top ¼ of the head and a second ear (showing
only half) on the other side. Make a second triangle to
follow the external lines. This is creating the inner
part of the ear. Finally add some tufts of fur to the
ear. For the nose, create a partial triangle and shade it
in. Then, for the mouth, simply add a simple smile
from the chin line to the length you desire. You can of
course change the lines to create the mood you're
seeking.

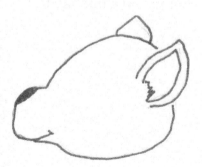

To create the face, add some cheek fur. To do this you
will add a distorted C curved zigzag to the right or left
of the mouth, about half way up the cheek. Then add
the eye of your choice. This look may vary from
character to character. The eyes created earlier will

act as a guideline for you. To create a neck, simply add
a curved rectangle beneath the head; from just below
the furry cheek to just below the ear, like this...

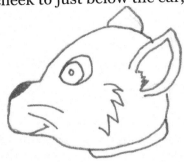

Now that you have the cat's head, it's time to create
the upper part of the cat's body. To do this draw a
'loose-line' from the back of the cat's head until you
reach the end of where you'll put the tail, round the
end and return the line in an equal width until you
reach the buttocks of the cat. Then draw a short line
downward from that point. Then add a small line also
below the chin, like this...

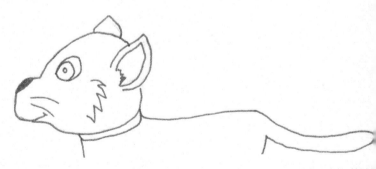

To continue creating this cat, extend the lines at the
rear and chin downward to create the front and rear
leg. Do a matching line to create the leg's width.
Create a third and or fourth line needed for the
opposite side (you won't need to do a full leg, and you

will want to make it slightly 'smaller' to appear further away. You don't want it to look like all four legs are on the same side of the body). Once you've created the legs, create the belly by linking the underside together. Make the front part thicker than the rear and then add a second line beside that to indicate the underside. (This is great for creating belly definition).

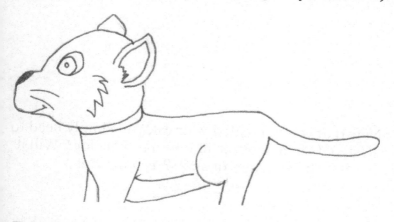

To complete the cat's shape, you're going to add the four paws. For the rear leg and front leg closest to you create a series of small c's—three or four should do it, then round the bottom, curing it upward to the opposite side of the leg. For the legs furthest away add a few toes, but you may not need as many and do not need to make them as defined, like this...

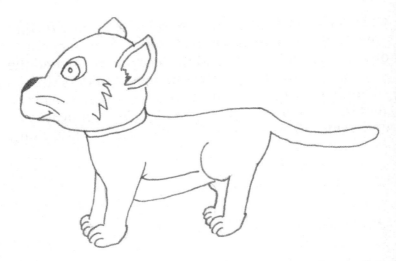

Now that you've created your cat, you simply need to design its final look. Will it be a solid color? Will it have stripes or spots? You decide!

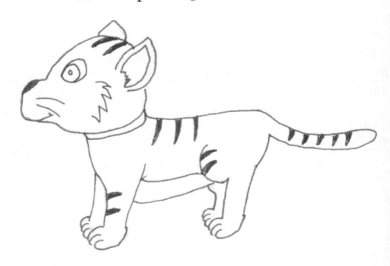

The Cat with clothing...

Virtually every animal you cartoon is able to be clothed. Some characters, like a snake or snail, might not need as many things as a cat or dog, but experimenting is always encouraged.

To create your, walking and clothed, cat follow these steps...

To create your clothed cat, you will start with your cursive C mouth and nose. Then create the circle that will become its head. Add the two triangular ears (if you are doing this as a rabbit or a dog, change the ear type.

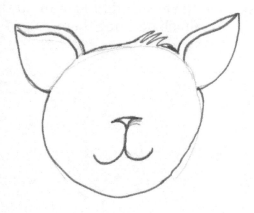

For the rest of the face add your eyes, which ever you should feel best suits your cat character, then add the curved zigzag face on either side of the nose. Then, to complete the face add the U chin beneath the mouth.

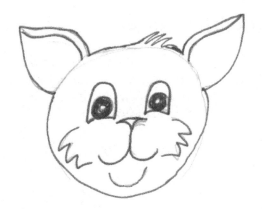

Now that you have your cat's main face, try adding a few extra features. Where you had the left ear create the small b baseball cap and erase your ears. Then create outer cheeks to create more kitty like features. Add whiskers to the face and tufts of fur at the ears to finish defining them.

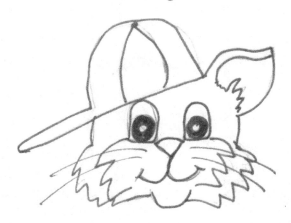

Now that you have your cat's face, you're going to create the body. To do this start by making the neckline. To do this you will create a circular shape beneath the chin with a duplicate line beside it to create the collar of the shirt. Now create the shoulder

creating two curved lines to create the sleeve of the T-shirt. If you want a longer sleeve then create the line further down the arm. Once you've created the outer side of the sleeve move a line inward and do a partial line to complete the sleeve. Then create a straight line moving downward towards the waist. Move that line across his midsection and back up to the other side to complete the full t-shire. Once you've completed the shirt, you're going to create the two arms by moving two lines in whichever direction u wish. IN this case we had one moving towards his waist and the other upward. Create an object if you wish or simply create the hand. In this case we created a baseball and glove.

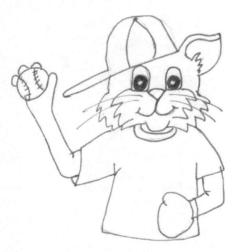

nally, to create the character we will create the lower half. To do this you will create shorts or pants. To create your pants or shorts add the 'box or rectangle below the waist line and finish it by adding a middle ne to separate the legs. Add two curved lines at the ps to indicate pockets if you should so desire. Once e shorts are done you will need to finish the legs by

making two squares or rectangles and then create th
socks by creating the cuff (a rectangle) the sock
(second rectangle) and the shoes (two ovals). Add
your laces and soles as desired. To finalize your
character, add any distinguishing features, like the
ring tail.

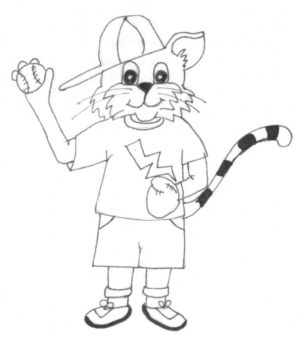

Lesson Eleven

People Characters

As you will note there are various individuals to create and with each you will encounter issues like height, age, weight, and ethnicity. To create an example of each, follow these tips.

Body Shapes and Types

Because people come in a variety of sizes and shapes, we will take you through a few steps to create different looks for your human characters.

Larger Body Type

To create your shorter, plumper person, think circles and pears. Follow these steps to create your plump man. Below we will be creating the ever popular overly plump friend of children; Santa Clause!

Start your Santa by using a general face shape. Oval or round will work well. Then create your eye choice. Now above the eyes create a fluffy lined cloud to create the brows. Now create the J nose and then directly below that, create the mustache; a fluffy zigzag beneath a partial circle will work for this. Then, on either side of the head add your ear choices. Pencil in a large fluffy cloud moving across the brow

to create the fuzzy lining of Santa's hat. Finally create wavy lines from the ear to the mustache and then a wavy and fluffy U for the beard. Finally create a little oval beneath the mustache to indicate a mouth or lips like this...

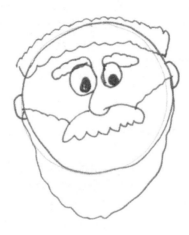

Erase your extra lines to tidy up your face...

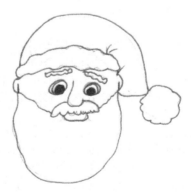

To create your Santa's upper torso; create a broad and wide bottomed U. Then create the fluffy belt around

ᴉe waist and another ruffled oval from the chin to the waistline.

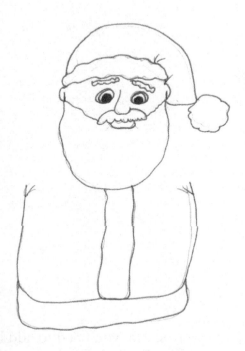

To create the arms, draw large rectangular or oval shapes on either side. To create a curved arm, try ᴣing the larger C or G as a guideline. Once the arm is made create he fluffy wrist bands. Finally, to create he mittens, a simple loose circle will work. Oh, and on't forget Santa's sack. To create this; simply add a tiny triangle on the inside of the hands and then ᴐllow a smooth line behind his back, creating a large O behind the opposite shoulder.

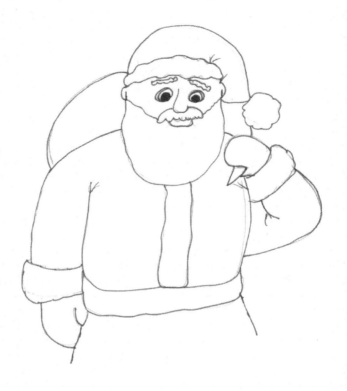

To complete your Santa, you need to add his lower half. Create a wide pair of U's for the legs. Add fluffy cloud band around the bottom of his pants. Then to create the boots, create your oval shape. Add a bit of detail to create the sole. You may want to add a belt or buckle to your Santa—that's up to you and your creativity.

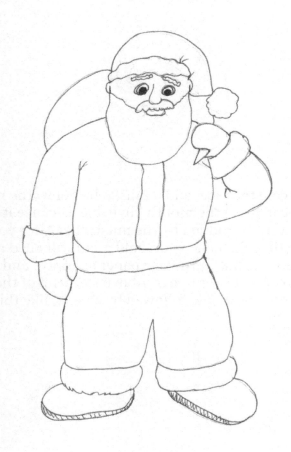

n older man

create a different look, try creating an older man.
re's how you can do that.

3egin by an inverted oval and then add your C or J
 nose and two circular eyes.

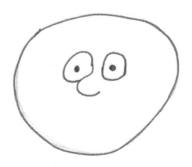

To create the face; add a mustache below the nose
You can leave the mouth 'invisible' because it will
appear to be hidden by the mustache. After you've
made the mustache your 'bald' man will need a hat
To create the hat, turn your paper sideways and crea
a large C from ear to ear. Above the brim of the ha
create a rectangle followed by a peak, like this...

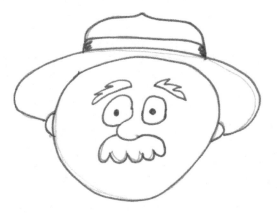

Now that you've created the neckline, create two wi
triangles below the chin, like this...

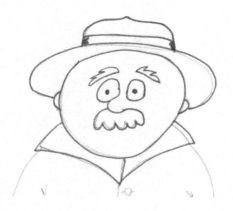

To begin the length of your body; create a large and wide U which will not go to the neck. Move the lines into the position where the 'armpit' region will be. Beneath the U create a wide and boxed capital W for the pants. Then in the jacket or overcoat part of the coat add to large U's and add the line to close the opening; this creates the pocket.

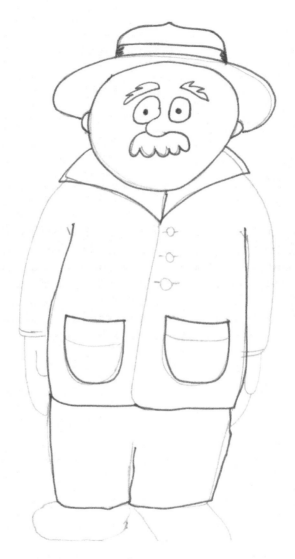

To finish your character, create the arms by drawing
the line from the collar to about half way down the
man's body and then moving that line inward towards
his hips. At this point you can create the hand or glove

of your choice. Then to finish the whole image, create the oval feet. Feel free to add laces as needed.

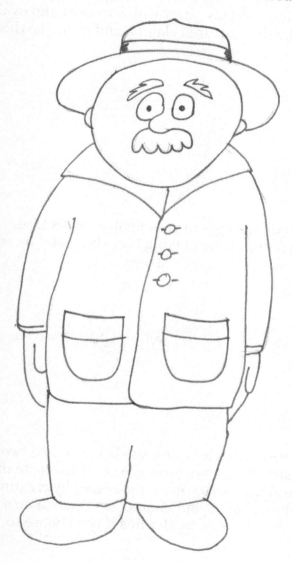

**Slender lady...**

To create your lady; start with a narrow and oval fac
Make the chin area 'dainty' and thin, like this...

Now add the eyes of your choice to this face. Make
them feminine by making them bold and by adding
lashes.

To continue this look at a small J nose and two parti
c ears. Put earrings on your ears to create more
femininity. Now complete the face by creating the
mouth that suits your character. You can do a simpl
smile or do bolder lips if you choose to.

To complete the head; create a waved pattern for the hair.

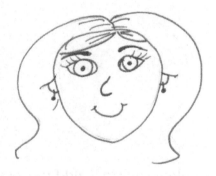

To create the upper portion of the body, think back to the figure 8. Use the shape to help you hourglass your body figure. Smooth the lines to create your blouse or dress or skirt. Then create a V neckline of your wish. You can also create a U, a heart, or circular shape, add ruffles if you wish. A beaded necklace can be added by simply creating many tiny circles in a row around the neckline. To create the arms, create two ovals. One for the upper arm, the second lower arm. Smooth out the connection by creating your elbows. Finally, create the hands by either resting them on the side, placing them in a pocket, create a pal, or simply create the fist and place balloons or flowers in it.

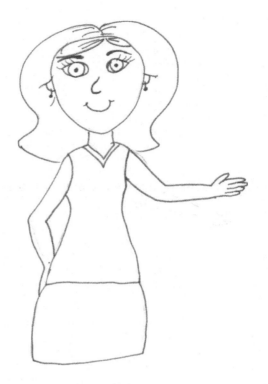

Finally, to complete your look add the legs. To do th
create two long and thin ovals, shape their angle an
follow up by adding tiny shoes. Tiny feet are
feminine.

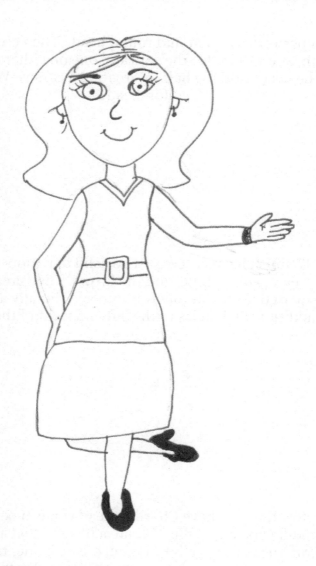

Character creating...

Try Charlie Brown. Based on the instructions you've learned to date, this character will be fairly straight forward.

A perfectly circular and round head. Then create the three c's. Two for the ears and one on either side of the head. Add the hair by creating a cursive W to his forehead.

To finish his face, create two solid dark dots for his eyes, add a smile, and the brows. Then create a squared neck, but follow it into a V. Finally add two additional triangles to the left and right of the neck.

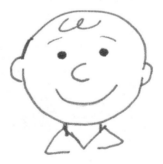

Now that you have Charlie's head you can begin the middle portion of him. Create a boxed waist and then from the collar to elbow region create a line, move the line inward towards the belly. With the shorts create a wide W. Then finish this section by adding the arm extensions.

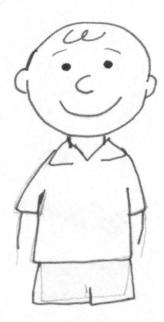

To complete the look; create two legs, using squares and ovals. Then finish the hands by simply letting them hang by his side or try one of the curved elbow tricks. Finally create the black zigzag across this tummy and don't forget that his shorts are also black.

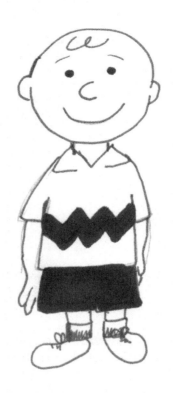

Lesson Twelve

Creating the Unusual

One thing that's truly fun about cartooning is the ability to create fictional characters. Fantasy or sci-fi; it's virtually unlimited. If you can see imagine it, it can be cartooned. Below is a simple...

Rules are practically non-existent when creating the Alien and Fantasy character. To illustrate this particular character simply create an upside down pear. Now created two lollipop shaped eyes (two circles and two rectangles), then create the black circles for the pupils.

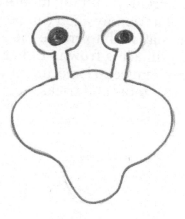

Now that you have the head, simply create a long 'gooey' shaped body.

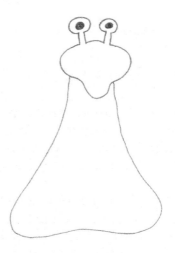

Finally add two feet (ovals), an inner belly, and two
arms with hands. Don't worry about length or elbow
just let it be different. A smiling mouth and brows t
set the mood of a friendly alien can be created here
Otherwise, you may wish to create the angry eyes an
then create a grimacing frown. Either way, let this
lesson be your chance to experiment with all your
tools and tricks.

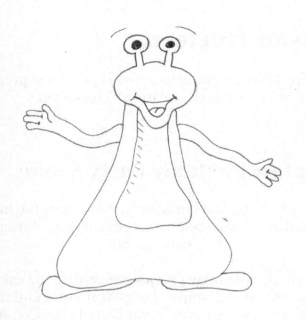

Lesson Thirteen

Creating all your characters to this point has prepared you for your next task; creating a story scene.

Create a Birthday Party Scene

Because animal characters are so much fun and versatile, we will create our scene using a variety of characters.

To begin our birthday party scene; create the cake. To create the cake; simply draw a trapezoid and then create a rectangle in the lower half of the cake. Add a few flowers or balloons to create the decorated look and write happy birthday to complete the cake's look.

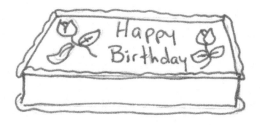

Create the Birthday Character...

to create the birthday character. In this case the character is a rabbit. To create the rabbit start with the cursive C; which you will place approximately 1 to 2 inches above the birthday cake. Then above the Cursive create two arched eyes. These eyes indicate joy and pleasure. They do not have to be opened;

However, you could do large eyes to capture a surprised look, like this...

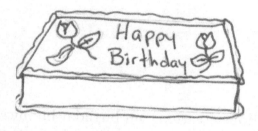

For the next part of the cartoon you're going to create his face and ears. To do this pencil in a fuzzy U under the chin and tow pointy ovals for the ears. Create an inner layer to add definition to the look. Once you've done that add some tufts of fur to the ears, like this...

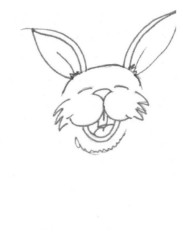

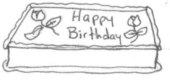

To continue creating your birthday bunny start by creating the shirt. To do this, simply make a square from beneath the cheeks down towards the waistline Then move the line across to create the bottom of the shirt. Now you need to create the sleeves by running two parallel lines from the shoulder to about the same length of the waist (where you will be putting the hands). If you decide you'd rather create a T-shirt, simply cut the sleeves shorter and make the extended portion fluffy and slightly smaller in width the the sleeve. Now it's time to create the hands. You can simply create a paw by making a rounded oval and a thumb (like a mitten), or get creative and try creating your hand-paw. You can make his paw with three o four fingers and then the thumb. To define the wrist

and glove region you can add an oval cuff to the sleeve.

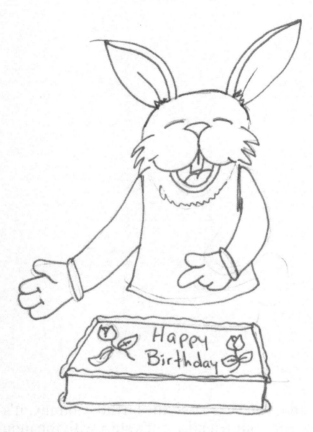

Now to complete your rabbit you can add whiskers to the face if you wish; two to three is usually the standard. Then, for his bottom area, simple link his shirt line to the table and then create a puffy tail in his buttocks region. Finally, decide which feet you want under the table. Do you want a defined paw, a booty, or shoe: you decide...

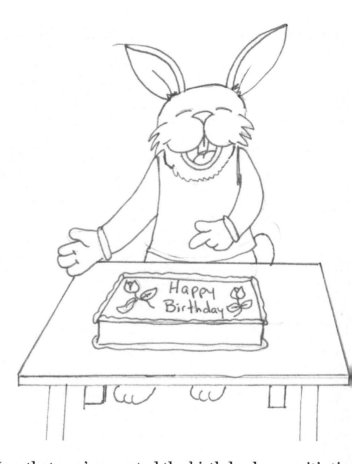

Now that you've created the birthday bunny, it's tim
to create your friends. Let's start with the mouse's
head. Like earlier, create two circles one in front o
the other. The front circle should be smaller than th
back one. Then smooth out the lines to create a lin
between the two, create a point at one end, add a thi
'dot' nose, and then create your mouth. You can
simply smile. For this mouth I created the open
mouth by extending the lower jaw slightly and the
creating the inner inside features (tongue and lip)
Then add a few whiskers to the mouse on either sid

of the nose. Now decide which eye type you are interested in. Will your mouse be close eyed like the rabbit or have great big happy eyes. Maybe your mouse will be unhappy and jealous. In that case you can turn the smile into a frown and create the angry eyes...

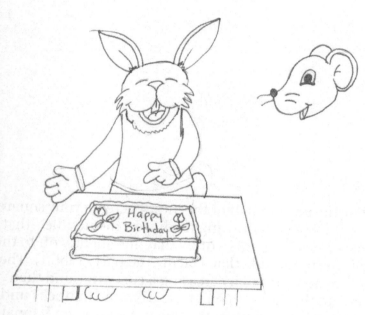

Now the mouse will need a body. To do this; create the shirt in much the same way as you did for the rabbit. To create the side view, move the sleeve towards the front of the shirt and then move the arms forward towards the character. For this "action scene" angle the hand towards your rabbit and create some speckles of confetti, like this...

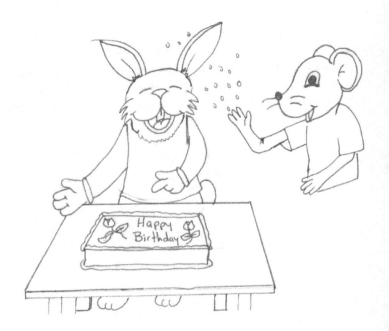

For the bottom half of the mouse, create your square, but instead of drawing the line in the middle—that separates the pants—draw that line slightly off to the left (or to the side that's facing the party rabbit). Then create your tail by creating a curvy line and then create the line a second time from the buttocks until you come to the tip of the tail at the other end. Finally create your legs and feet. To do this, draw your rectangular shapes for the legs, create the socks using smaller rectangles, and then add two ovals for the shoe. You can also do a bear leg and create the mouse's toed foot instead.

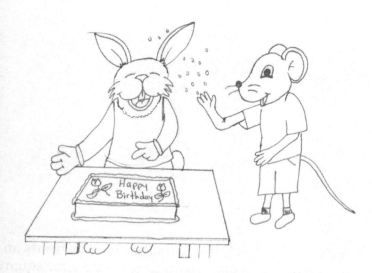

Now that your mouse has been created, let's add
another friend to the party. Start with your cursive C
and then, like the rabbit, create the dropped mouth
(teeth and tongue may be put inside the opening to
help with identifying with your animal's character).
Now create the eyes; in this case the cat is as happy as
the rabbit. Then create a light penciled circle around
the face and then use that to create zigzag fuzzy
cheeks, ear tufts, and top of head. For your ears,
create your smoothed triangular ears. Use the inner
line to create definition, like this...

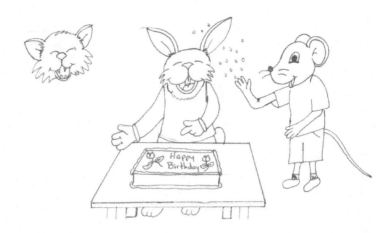

Your cat is enjoying the party, but he now needs an upper torso and arms. To do this; create your square body, running the line from just below the cheeks to the hip/waistline. Create your sleeves by creating two equal lines and connecting them at the end (where the wrist will be). Create the angle of the cat's arms by moving the lines outward. Finally, add the hands or paws to your cat as you wish.

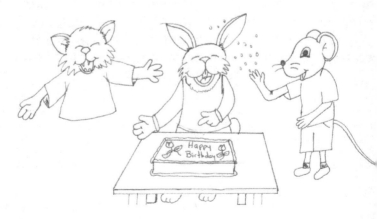

Your cat now needs a bottom half. To do this create smooth lined square and add your line to create the

ivision between the legs. Add two ovals at the base of the pant to create his feet. Finally, add his tail; ¬eate an extended oval from his buttocks to the tail's end. This is your character. Your cat can have an extra-long tail, and short stubby tail, or a big fluffy one. It's up to you.

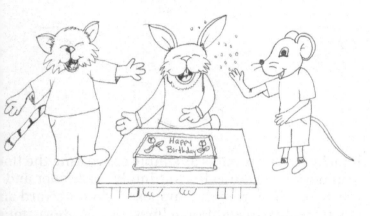

Let's get the party started! To create the fun in your rty; add some balloons. You can also add streamers nd more confetti as desired. To create your balloons simply created multiple circles. Each balloon will receive one angled # symbol to indicate volume. alloons do not have to be circles each time; you can lefinitely experiment by creating balloon dogs and giraffes. As you get better with your ovals and shaping you will be able to enjoy the versatility of alloons. Once the balloons' shape has been created, you can now create the floating vessels by creating y circles beneath the balloons (this circle is the knot hat keeps the air inside the balloon). Now create a angle beneath the knot. Finally, create a long curvy ne downward from the triangle to the floor. This is your string!

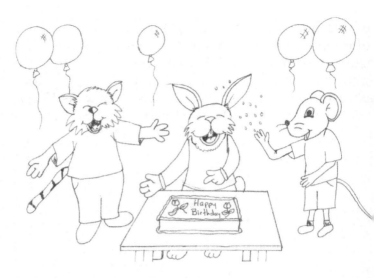

Finishing your room is as simple as creating the floo
and wall by adding lines. Simply use a ruler and
create one line from the 'supposed' floor upward an
then create two additional lines; one is a horizonta
and the other has an angled line. This simply creat
a room space. You are able to create art and windov
as you desire. These are simply created using squar
and rectangles as needed.

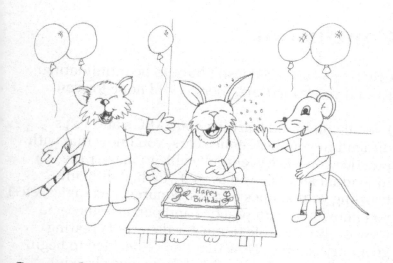

Congratulations! You created your first cartoon. It's
time to celebrate!

Conclusion

Creating a cartoon doesn't have to be intimidating. Even if you *'failed'* art, there is still hope for you.

Even if you found learning your ABC's and 123's difficult in your academic years, you know that with practice you were eventually able to master the individual letters. And even if you had difficulty learning your shapes (circles, squares, rectangles, etc.) you know that with practice and perseverance you were eventually able to master the art of creating geometric shapes. Now that you've decided to begin cartooning you can use the skills you've already learned as your stepping stone to this art form.

Like any art form, the more you practice, the better you'll get. The guidelines listed in the preceded chapters will aid you in the process of learning to cartoon. Remember that an A doesn't simply have to be an A. The A can be a mountain or the aid to creating a gnome's hat. Inverted the A can create a cone. The A is practically a triangle and either will aid you in an assortment of images.

Learning to see art in objects and even in scribbled mistakes will aid you in becoming more creative. It's not an impossible task to see an elephant in a chicken leg, if you know how to see the shape as a shape. Don't see it as a chicken leg, but rather look past the obvious and see what's unique about its shape.

Although it sounds like kindergarten in some ways, drawing your alphabet, numbers, and shapes will help you get your cartooning hand warmed up. Then, for

the sake of starting out, use each shape or letter as a basic outline to a character. Let the object your drawing create itself.

Frustration sets in when you try to force the creation of an image. Rather than allowing the problem to arise, give yourself time to practice and warm up before drawing your proposed character.

Keep this in mind; before a pianist can perform before the Royal Family in a glorious concert, he or she must be prepared. How this pianist prepared began with an interest, from there he or she took lessons and practiced daily. Many famous pianists attest to practicing several hours a day! As they learn more and practice more the art becomes increasingly honed and polished. By the time he or she is playing for a grand audience he or she has invested years of practice and perfection.

Like the pianist, cartoonists had to begin drawing as children and with a hunger and interest in the subject they spent many hours drawing. Not even Mickey Mouse was created in a day. In fact, Mickey Mouse's look has changed over time because the artist, Walt Disney, spent many hours perfecting his now loveable and infectious look.

Dozens of pencils and erasers were killed during the making of this book, because many drafts had to be done before I found one that was suitable to aid you in the learning process. With each image these drafts were done in pencil, reshaped, smoothed, and then eventually inked to complete the final look.

Regardless of what it was that made you decide to learn how to draw cartoons, the fact that you're interested shows that you already have potential. Be willing to try these different steps. Be willing to do many trial and errors before you get it right. And above all, be willing to have fun. The art of cartoonir is entertaining, inspiring, and can be endless. For every famous mouse, cat, dog, or monkey there was i inspired soul just like you. Let the inspiration flow from your pencil and never let a mistake be a deterrent, let it be the stepping stone to your next inspiration. The art of cartooning is in your hands; enjoy every minute of it!

About the Expert

Kim Cruea spent her academic years in Newmarket, Ontario. She attended Glen Cedar P.S. during her early years and later attended Huron Heights Secondary School, and it was there; through the guidance of her grade nine teacher that she would discover her passion for writing. Now a resident of Barrie, Ontario, Kim writes full-time as a freelance writer. She is a loving wife and grateful mother of two children. For more information on Kim Cruea, you can find her on Twitter & Facebook.

HowExpert publishes quick 'how to' guides on all topics from A to Z by everyday experts. Visit HowExpert.com to learn more.

Recommended Resources

- HowExpert.com – Quick 'How To' Guides on All Topics from A to Z by Everyday Experts.
- HowExpert.com/free – Free HowExpert Email Newsletter.
- HowExpert.com/books – HowExpert Books
- HowExpert.com/courses – HowExpert Courses
- HowExpert.com/clothing – HowExpert Clothing
- HowExpert.com/membership – HowExpert Membership Site
- HowExpert.com/affiliates – HowExpert Affiliate Program
- HowExpert.com/writers – Write About Your #1 Passion/Knowledge/Expertise & Become a HowExpert Author.
- HowExpert.com/resources – Additional HowExpert Recommended Resources
- YouTube.com/HowExpert – Subscribe to HowExpert YouTube.
- Instagram.com/HowExpert – Follow HowExpert on Instagram.
- Facebook.com/HowExpert – Follow HowExpert on Facebook.

Made in the USA
Las Vegas, NV
29 December 2020

14969080R00095